THE PICTURE MAN

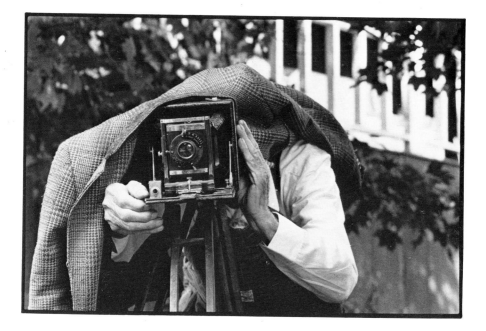

Edited by Ann Hawthorne

PHOTOGRAPHS BY PAUL BUCHANAN

Foreword and Introduction by Bruce Morton

The University of North Carolina Press *Chapel Hill and London*

THE PICTURE MAN

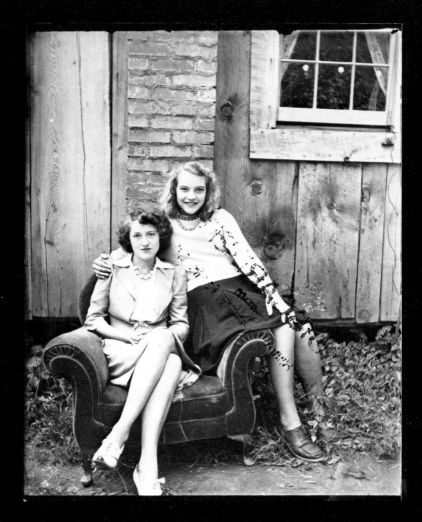

© 1993

The University of
North Carolina Press

All rights reserved

All photographs by
Paul Buchanan © 1993 by
the Estate of Paul Buchanan.
All photographs by
Ann Hawthorne © 1993
by Ann Hawthorne.

Manufactured in the
United States of America

Design by Richard Hendel

The paper in this book meets
the guidelines for permanence
and durability of the Committee
on Production Guidelines for
Book Longevity of the Council
on Library Resources.

Library of Congress
Cataloging-in-Publication Data

Buchanan, Paul, ca. 1910–1987.
The picture man / photographs
by Paul Buchanan; edited by
Ann Hawthorne; foreword and
introduction by Bruce Morton.
p. cm.
Includes bibliographical references
and index.
ISBN 0-8078-2119-5 (cloth: alk.
paper).—
ISBN 0-8078-4431-4 (pbk.: alk. paper)
1. Mountain whites (Southern
States)—North Carolina—Pictorial
works. 2. North Carolina—
Pictorial works. 3. North Carolina
—Social life and customs—
Pictorial works. I. Hawthorne,
Ann. II. Title.
F255.B86 1993
975.6—dc20 93-7368
 CIP

97 96 95 94 93 5 4 3 2 1

For Paul Buchanan and those who stood before his camera

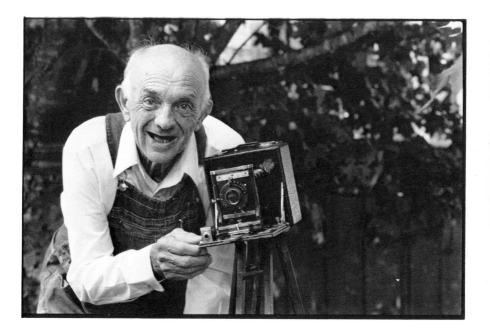

CONTENTS

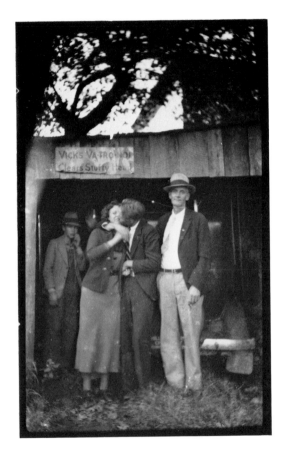

FOREWORD

History is bits and pieces first. History is stuff, patches of the quilt that is our past.

The grand designs come later: the pattern of the early settlements shows this or that; the Industrial Revolution happened because of iron, or men. That's the historians, the maestros of the past, arranging it.

They make patterns, but in the beginning, history is things: census records, old letters in great-grandma's trunk, a diary from a half-forgotten war. Piano rolls, pressed flowers, someone's recipes. And pictures. Just think how much we know from pictures, starting with cave drawings, and moving on.

So what's in this book is history, not patterns but pictures. They are the work of Paul Buchanan, who for nearly thirty years, from the 1920s until 1951, wandered four North Carolina mountain counties—Mitchell, Avery, Yancey, and McDowell—and took a lot of pictures.

If a gifted photographer goes to a place—whether or not he knows he's gifted—and if people stand up for that photographer, maybe none of them know what they are doing is important. But what you get is a picture of that place at that time.

Here they are, then, the people of those four counties as they posed, during those years, for the man they called Pic-

ture-Takin' Paul, the Picture Man. We don't know most of their names. But we learn things from their faces, from the clothes they wore, from the things they wanted the Picture Man to see.

"If I did take them," Paul Buchanan said, "they're good pictures. Good and plain." They are that, but they are something more as well. They are history, or some of the stuff that history is made of: a few more pieces of the quilt that is our memory, that tells us who we were and who we are.

<div align="right">

Bruce Morton
Washington, D.C.
1992

</div>

PREFACE

Paul Buchanan did not think of himself as a photographer, and at our first meeting, neither did I.

My only guide to him was an unsigned note left tucked behind a photograph in an exhibit I had hung in Bakersville: "There's a man with old pictures of this area you might want to meet, Paul Buchanan in Hawk."

The general store was still the center of Hawk in 1977. I stopped there to ask about Buchanan. Looking out the window across the road, the owner said, "He ought to be at home. I haven't seen him go out this evening." He directed me to a red board-and-batten house on the nearly vertical hillside by Polly Branch Road.

Paul came out onto the porch when I called from the yard. After introductions he invited me in to meet his wife, Ola. We talked a while, politely, mostly seeking names of people we knew in common. He pulled out a tin of pipe tobacco and as he started to roll a cigarette he looked over at me, laughing, and dared, "I don't suppose you'd know how to roll one of these the old way, would you?" I told him I'd be willing to try, and after a few failed attempts and coaching tips produced, to his obvious pleasure, what resembled an arthritic finger barely

stable enough to withstand the force of a match flame. "Well," he said, "I guess you're all right."

I asked about the old pictures that had prompted my visit. He told me as he looked around the living room that he had a few around somewhere but he wasn't sure where. On the walls and framed on the heater, dresser, and side table were family photographs—sons, daughters, and many grandchildren. Scanning the room you could see them grow up, caught year by year in color studio and school portraits.

Paul told me he still had his cameras. He offered to get them out for me and to look for his old negatives if I would visit again. I said yes.

Our visits were arranged by letter, since Paul and Ola did not have a telephone. I would write suggesting a choice of days. Ola would reply for Paul telling me which day they would look for me.

It was warmer the day of my next visit. We sat on the front porch sofa looking straight across into the facing mountain-side. Amid talk of health and weather, the garden, and his dog, Snowball, I learned that our previous sharing of acquaintances had not been so idle. Not only had Paul been looking for my references, he had checked with them about me.

The end of the porch nearest the front door had been closed in, creating a small room no larger than three by six feet. Although it had become a catch-all storage space, it once had been Paul's "little room"—his darkroom and photograph-

ic closet. Out of that little room first came empty boxes and sacks and then the five-by-seven-inch brass and rosewood portrait camera Paul had inherited from his father, Fate Buchanan.

It looked brand new. He told me, "My cameras will go to my grandson one day." Altogether, Fate and then Paul Buchanan had made photographs for a span of fifty years. Paul thought of the camera as his legacy.

As I started to leave, he dug deeper into the little room and brought out the first of several open cardboard cartons filled with negatives. A few were in four-by-five-inch or five-by-seven-inch Kodak boxes. Most were loose, glass plates and sheet film alike. "You take these films on home with you. See if there's anything that interests you," he insisted. Looking at those on the top of the pile I could not imagine there was anything to see. Many appeared ruined. All were filthy.

One night, curious about whether I could salvage any of the glass plates, I pulled out a stack of four-by-fives. The first was shattered; the second, opaque from the dirt accumulated through years of abandonment. I cleaned the glass side of the plate. When I held it up to the firelight, there was the image of the young boy now on the cover of this book. I spent the night cleaning glass and the next day making contact prints.

I was stunned by Paul Buchanan's photographs. Few of the negatives were ruined. They were printable. And the images they held were beautiful. While Paul looked through the prints, I told him that he was a wonderful photographer. This

comment pleased him, but he continued casually looking through the prints. "They are right good yet, aren't they?" Then Ola and Paul searched for faces they recognized.

His photographs had served their purpose years earlier. Their value was spent for him at the time they were made and paid for. Receipts for film and chemicals were stored far more carefully than the negatives. Taking pictures had been a business, not a mission or an art. For years he had supplemented his income in a way he enjoyed.

Paul Buchanan was a simple man, free of pretense. His pride in his work was in the photographs' being "good and plain." When he did his job well you could clearly see who the subject was. It would "look just like him." His reward was to be paid for his work.

While Paul would "pick out the place" or "find a bunch of flowers," it was the people themselves who directed their presentation and its record. They are here as they chose to be seen. We may presume that the character we sense of these people from their photographs—bashful or self-conscious, cocky or proud—and the stories we spin around them grow from real clues offered within their surroundings, not from the photographer's creation.

At the same time Paul Buchanan was working, Doris Ulmann was photographing southern Appalachians only a few counties distant. Their images could not be more different. Paul Buchanan's subjects were his neighbors; Miss Ulmann's,

"Appalachians." People around Brasstown, North Carolina still talk of Miss Ulmann's visits from New York with her big car, unusual clothes, and her traveling companion, John Jacob Niles. She painstakingly selected and posed her subjects, often having them dress in old, quaint clothes. Through her they became less individuals than icons, embodying her admiring but romanticized image of Appalachians. Her exquisite images could be from an earlier century. Doris Ulmann was a photographer and artist. Paul Buchanan was the Picture Man.

Similarly, Muriel Sheppard and Bayard Wootten came to the mountains and in 1935 published *Cabins in the Laurel* (University of North Carolina Press, 1935, 1991). They covered not only the same time as Paul Buchanan but also the same counties: Mitchell, Yancey, and Avery. *Cabins in the Laurel* is still referred to by some of the area's locals simply as "that book." Like Miss Ulmann, Sheppard and Wootten had produced an intimate love letter to a changing region, a letter that revealed their impressions of an earlier time. Their subjects did not recognize themselves.

Paul Buchanan, on the other hand, did not try to explain or interpret his subjects. He held up a mirror that shows us their reflection. He was an insider, himself an Appalachian. Paul lived much as his neighbors did. He owned his house and the land around it, a stone's throw down the branch from where his father had lived. He spent his entire life in the shadow of Little Fate's Mountain. He had a garden, some apple trees, a

few animals. He did some farming, some sawmilling, some mica mining, some picture taking.

The mountain land, with its vast resources and inaccessibility, shaped the life of its settlers. Their culture remained undisturbed, isolated and stable. They were mostly white, Scotch-Irish, and Protestant. They farmed on whatever scale their land and its topography would allow. They mined the rich mineral deposits—not coal but mica, feldspar, kaolin, gemstones. The forests provided timber and fuel, game and herbs. Some towns had developed as centers for commerce and hubs for transportation to outside markets. Families in remote pockets established smaller, thriving communities at crossroads like Hawk, centered around a church, a store, and a post office.

Their economy was based less on cash, more on creative subsistence. So their life closely resembled life as it had been there for generations. Paul said, "Money was scarce back then." While the Great Depression made cash even more scarce, the mountain economy was more adaptable than most. The land still provided food and fuel. The long-established barter system flourished: baskets for meat, photographs for rabbits. "Anything they had to trade on, I'd take it."

Change came more rapidly in the aftermath of the Depression. Government projects put people to work, brought electricity and built roads. People, industries, products could more easily move both in and out.

That change in access also affected Paul's photography. The hollows he traveled were no less remote, but families could travel more easily to the larger towns. There were studios where proper portraits were made. Inexpensive cameras were readily available to use for their own snapshots. The itinerant photographer was no longer needed. So Paul "quit fooling with it."

Each visit with Paul I would probe for more information about his life and how he worked. As he admitted, he was a "bad hand to talk." Our talks rambled. I constantly had to guide him back to photography. He was interested more in the present than in the past. While he often talked about money, his delight in getting out, roaming the mountains, meeting people, and taking pictures overlay all his stories. His memories were fragments, but over time we pieced together a sketch of his life and work.

He worked part-time, only in good weather and on weekends when families were most likely to be home. He knew he could have supported his family handsomely with photography, but he would get bored with the routine after a few outings and move on to something different for a while. Most of his pictures were portraits, and most of those he contact-printed. He did a lot of copy work, reproducing old portraits. He kept no records, rarely recognized the faces in the pictures. He remembered few specific places other than Lick Log, where he worked often. (Lick Log stood apart not only in

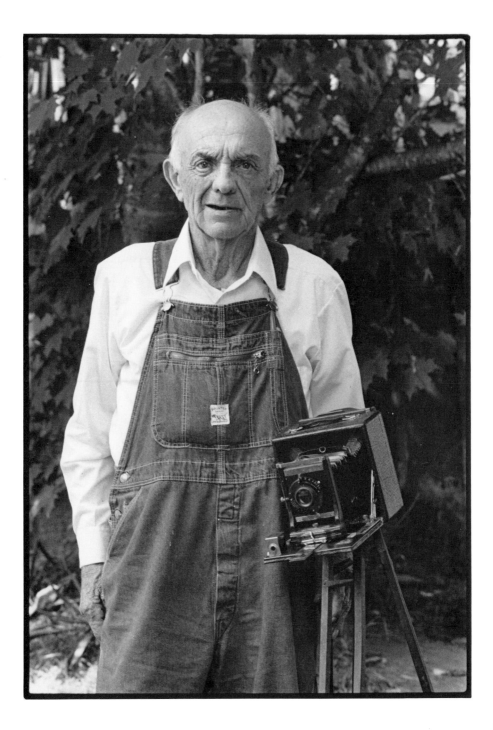

Paul's memory but also in the area as one of the separate communities where the few blacks in those counties lived.)

I believe I was the first photographer to spend time talking with Paul Buchanan. He was curious about how the business and techniques had changed since 1951. He became tantalized by the idea of shooting again.

I asked him one afternoon if he would make my portrait. He found his four-by-five, a tripod, and a partial film pack left over from his last trip. We went to the front yard.

"Where should I be?"

"That bush there makes a pretty background, don't you think?"

His black focusing cloth wasn't handy. Instead he took a sport coat from a nail on the porch.

"How do you want me?"

Silence.

"Paul, you're the photographer. Tell me what to do."

A grin. No instruction.

"Should I stand or kneel?"

"That's fine."

While he struggled beneath the coat and adjusted the camera, I photographed him.

"Am I like I should be, the way you want me?"

No response from the coat.

"Paul, help me out."

He peered around the camera and shed the coat. Grinning,

he looked me straight in the eye for a moment, then snapped the shutter.

The old film was ruined, but I have no doubt the latent image looked just like me.

Although difficult to resist, it is dangerous to make too many assumptions about faces in a photograph. The photographer, the subject, and the viewer, by what they each bring to the image, are all essential contributors.

Since 1977 I have sought to understand what it was I found so compelling about Paul Buchanan's photographs. What distinguished them from other collections?

Within the context of the region, I knew these portraits well. I had learned from Paul. Then, thirty-five years after Paul had taken his last photograph, he made mine. On the day I stood as his subject in front of his camera and watched him work first-hand, I gained an insight into the role of the photographer and the subject, the two aspects of the photograph separate from the viewer.

The effect of his working style was curious. While I faced the camera, he ignored me. His concentration distracted me from my self-consciousness. When he looked around the camera, his eye at lens level, the intimidating camera vanished. I was facing only a simple, straightforward man.

It seemed Paul imposed nothing of himself on me as he made my portrait. But in fact his effect on me was remarkable.

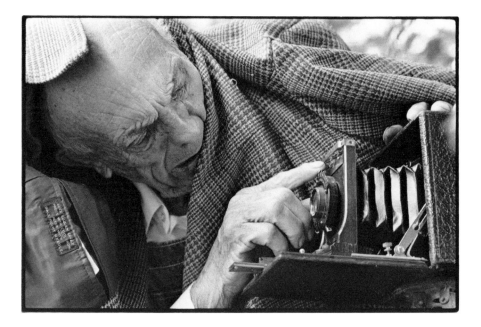

It is what happened in the best of his photographs, what makes them so honest. Free of artifice himself, he stripped me of mine.

That afternoon I met the Picture Man.

THE PICTURE MAN

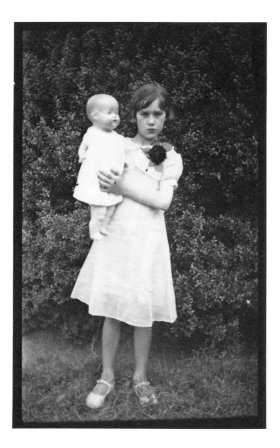

INTRODUCTION *by Bruce Morton*

Paul Buchanan was born sometime around 1910 and died in 1987. But there have been Buchanans in the mountains for generations.

Paul lived in Hawk, North Carolina. You have to go to the house with somebody who's been to Hawk before, because there are no signs to tell you where you are. It's a small wooden house, closed now though still fully furnished, and outside, on the porch, there's a small, separate room which Paul used as his darkroom.

We almost missed him. He hadn't taken a picture in more than thirty years when a present-day photographer, Ann Hawthorne, who was living in the mountains, heard of him and went over to say hello. He told her charming stories about how it was in the old days, and then offered to show her some pictures.

"He went back to this little room," Hawthorne remembers, "and he pulled out these cartons, these cardboard cartons, chock full of negatives, glass plates and regular negatives just thrown in there, nothing protecting them. They were totally in dirt. You couldn't see through them. Rats had been all through them; they were just a mess."

Hawthorne, determined, took them home anyway to see if

they could be salvaged. "I started looking at these things, cleaning them up a little bit, and just holding the negatives up to the light, I was amazed by what I saw. They were beautiful pictures. I was very moved by his pictures, and not just the subjects he shot, but the way that he did it, his work. And I was excited to come back out and see him, and tell him, 'Paul, you are a great photographer.' And I don't know that he'd ever thought of himself in those terms. He made some money. He made some people happy. But I don't think he thought of himself as a photographer. He was the 'picture man.'"

Hawthorne tape-recorded an interview with Paul Buchanan in 1985, two years before he died. The quotes in this book are from that interview, and we've included the full text.

How did Paul get started? His father, Fate, made pictures too, Paul said, but he never got much real instruction from his father. "My daddy, he imparted it. I don't know how he started. That was pretty close to a hundred years ago. He's the onlyest man around this country anywhere that done that kind of work. Fate Buchanan—everybody always called him 'Picture-Taking Fate.' And that's what they called me: 'Picture-Taking Paul.' . . . 'There comes the picture man.'"

Paul said his father did offer some advice. "If he'd see I'd made a mistake on something, he'd correct me on it. If I'd made one too light or too dark or something like that, you know. If I'd get too close to them, or too far back. . . . He'd tell me about it, you know."

But it may be just as well father didn't tell son too much. Some of Fate Buchanan's pictures survive too. They look ordinary, like snapshots. Paul's do not.

Paul did try to get one of his brothers to share the work. "I told him, if he'd go out and take them, I'd finish them up [develop them] and give him half of it. Well, he made a lot for me like that. I was wanting to go courting, you know."

The collaboration between the brothers didn't last long, but the courting worked well. Paul married Ola when he was twenty-one and she was nineteen, and she said the success he'd had taking pictures was one reason she said yes.

If customers wanted enlargements or color prints, Paul sent those to New York. But the regular black-and-white prints he made himself. The house is near a branch, and he used the water. "My daddy always told me to leave them [prints and negatives] in running water for an hour. A lot of mine I'd leave overnight. I had a place up here in the branch—a pipe running out. I'd have them in a dishpan and I just take them up there, put them under that, and leave them overnight. Well, that got all the hypo and stuff out of them. That's the reason they last so good."

He had a point there. It's not the way the corner drugstore does it nowadays, but the pictures Hawthorne printed for this book come from negatives that were fifty and sixty years old.

He traveled with plates and film, with one camera that made five-by-seven-inch negatives, another that made four-by-

fives, and two smaller Kodaks. The smallest, cheapest prints sold at four for fifty cents.

That doesn't sound like much today, of course, but it added up, back in the 1920s. Most people in the mountains then worked at several different things. There was some mining—mica and feldspar, mostly. Gathering ginseng in the woods brought money in. Everybody hunted; everybody farmed. Paul planted corn. One of the pictures in this book shows his nieces all dressed up; he'd promised a picture if they'd help hoe the corn.

But picture taking paid. "When I started out, if I made a trip making twenty dollars, I was doing fine. 'Cause twenty dollars then was twenty days' work. Dollar-a-day's what wages were back then when I first began in the twenties."

It was not, in the beginning, easy work. Paul started out on foot, walking through the wonderful old settlements with the singing names, through Buladean and Loafers Glory, through Clarissa, Bandana, and Pigeons Roost. But he was walking with forty pounds or so of camera gear, and the walks were all up and down hills.

"How did you decide where to go?" Hawthorne asked. Paul replied, "I'd just get to studying which would be the best place to go, and take off." "How far in one day?" "Back then I was young. I could go a long way."

He went, he said, to Mitchell and Avery and Yancey counties; he also "worked a lot in McDowell. It's a long way to go.

They's some territories I'd go in and nobody wasn't interested in pictures. Some I'd go in, and everybody wanted one."

The trouble was, of course, you had to make two trips. "When I'd go and take them, I'd come back home and finish them up. Then I'd have to take them back. I'd start out about daylight. Stay out sometimes after dark. Sometimes I'd stay all night at the last one. Sometimes I'd take a notion just to come on home."

He started on foot, but business got better, and so did the picture-taking life. "When I first began, I traveled walking. But after I got—when I got me a car, that's the way I went. First old car I ever had was an old '28 Chrysler. Money's scarce back then. I had an old mare and she'd foaled a colt. And I swapped that colt for the '28 Chrysler. And that's how I got around. From then on, I had it made."

"I'd just go and knock on doors. I always had some samples with me. If they was interested—look at them samples."

He was not a patient photographer. Often, as you'll see in these pages, people wanted to dress up to have their picture taken. This wasted Paul Buchanan's time and cost him money.

"I could have done a lot better if they wouldn't. But the biggest part of them took a long time to get ready. If they wanted to be made naked, I made them. It didn't make no difference to me. The money was what I was after."

Money, in those Great Depression years, mattered a lot. Years later, Paul remembered making some Sunday school pic-

tures and getting an earful on that topic from the preacher's wife.

"She said, 'Don't you know it ain't right for you to get out here and make money on Sunday?' I said, 'It ain't a bit more right for a preacher to get down here and preach on Sunday than it is for me to get up here and make pictures on Sunday.'" Her criticism annoyed him all the more because she had bought three of the Sunday school pictures herself. "Getting out that way," Buchanan said, "you meet all sorts of people."

He remembered, thirty years later, the woman who looked at a four-dollar print and said she wanted something better. He showed one just like it and said it was six dollars. So she ordered it, but never paid him. "I never did get a penny. I remember all such as that."

He remembered the man who didn't want to pay because he'd blinked just as Paul's shutter clicked, and wouldn't buy a picture of himself with his eyes closed.

And he remembered one profit-increasing device. Sometimes he'd send a postcard ahead that said, "I'll be here on Wednesday" or whenever, and people would be all lined up when he arrived.

He didn't like it when they kept him waiting while they dressed up, but he did carry one prop, a piece of cloth. "I'd stretch it up on the house," he said, "[and] if I could, I'd find a pretty bunch of flowers. And I'd have to wait for them. I got so tired of waiting on people to get ready."

And sometimes, of course, the people came to him.

He did it for the money, but in those days, in those places, people swapped a lot too. Pictures for chickens, Paul remembered. Once he swapped a picture for a lot of old peanut butter jars. He wanted to store jelly in them.

"One time, I'd made a woman's picture. She'd give me a big old rabbit for making her picture—one of them tame rabbits. I was coming home. Another woman looked in and saw that rabbit. She said, 'You mean to tell me you make pictures for rabbits?'" Well, yes, if the price was right.

Paul said he started taking pictures when he was sixteen or seventeen, and he did it for thirty years, up until 1951. When he quit, of course, it was money again. The world was changing. Radios, and the first small rumblings of the television age. Paul had done mica mining and sawmilling as well as photography, and he finally put his cameras away after a run that netted only seven dollars.

"I thought, by George, I'd quit fooling with it. And I quit fooling with it and went to sawing chair posts. 1951—that was the last work I done."

Paul Buchanan thought he was an honest picture man. He was, but his work shows more than that. These are posed, formal pictures. He didn't tell his subjects what to wear or hold. So looking at the pictures, we learn things about the people who lived in those four counties then. We learn from their faces; you can see the Great Depression there sometimes. We

learn from what they wore: some, come World War Two, are in uniform; some of the children wish they were. We learn what they were proud of: do you pose with the baby, or with the car? Some yearned for Hollywood. Some—you'll see—were so shy they hid behind a sheet he carried, and all you see is a baby propped up by shy, grown-up hands.

The Picture Man shot them all. He recorded the people of this place and this time, the way they wanted to be seen.

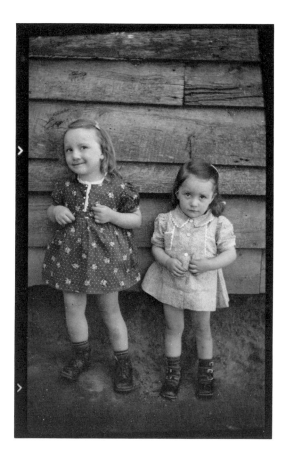

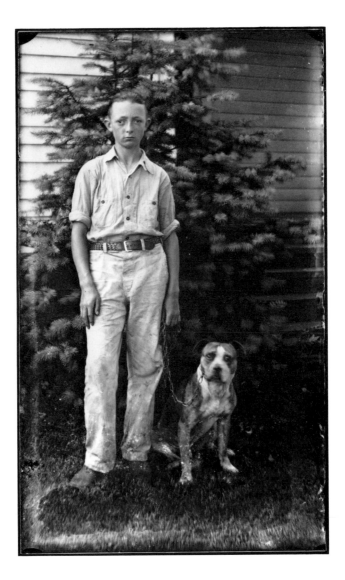

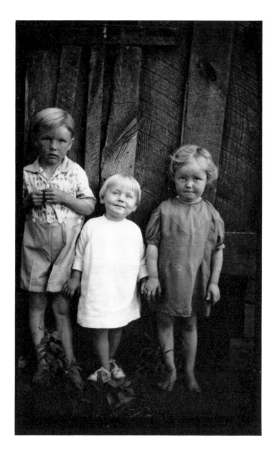

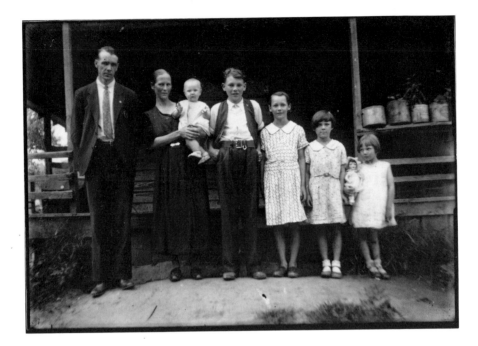

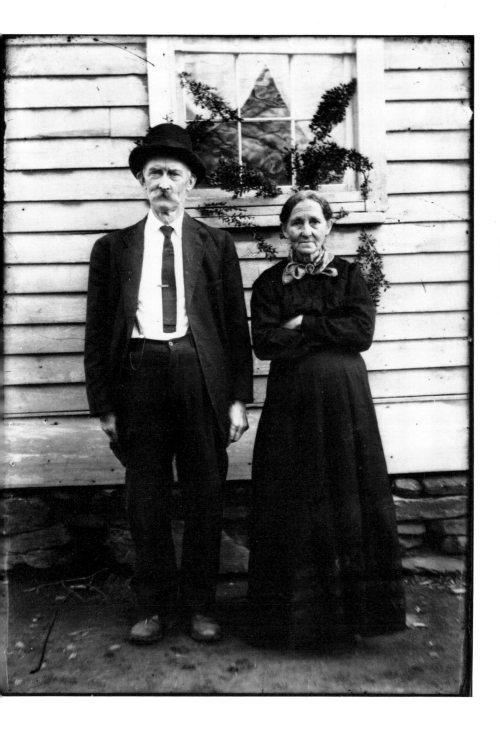

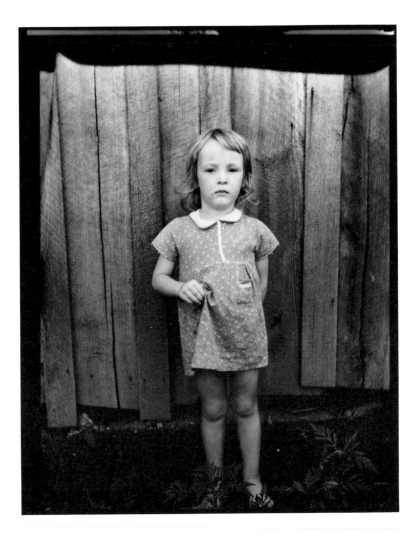

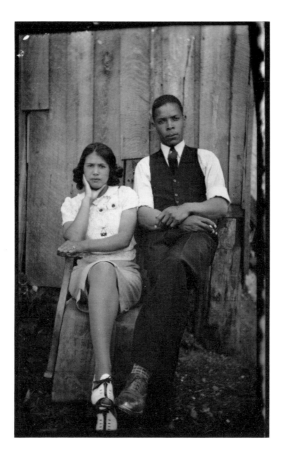

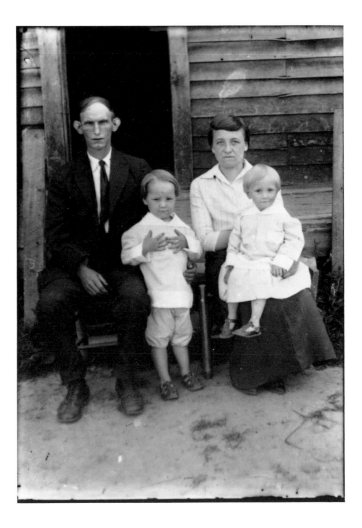

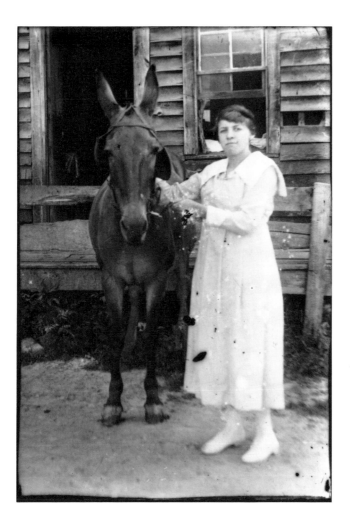

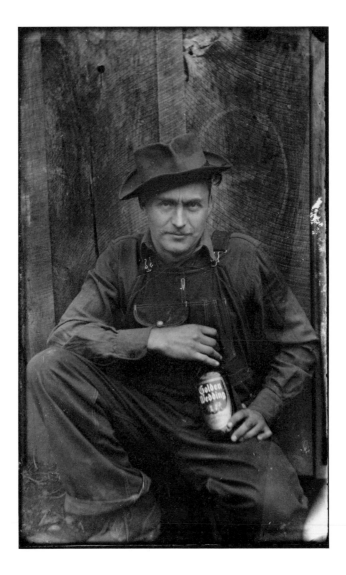

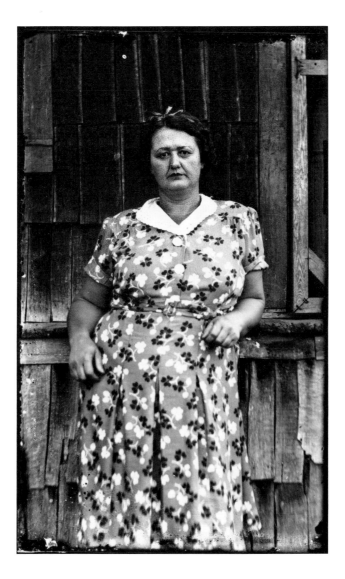

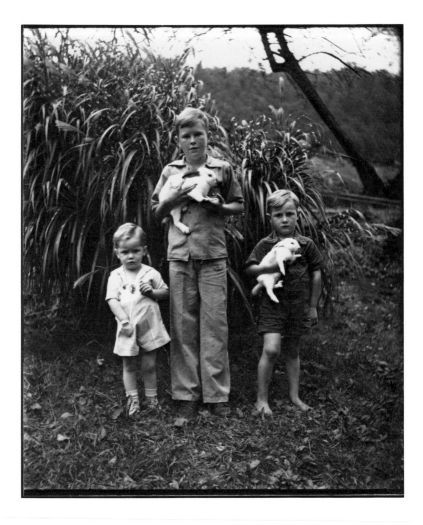

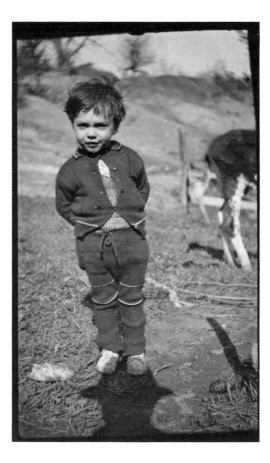

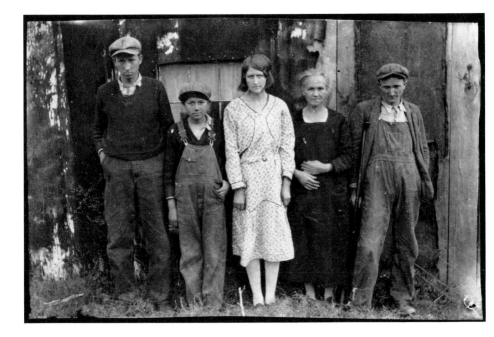

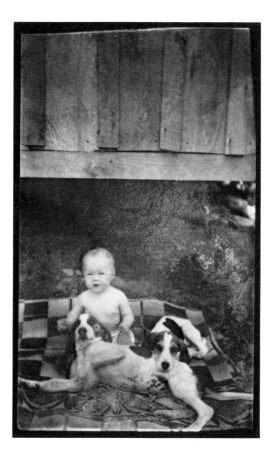

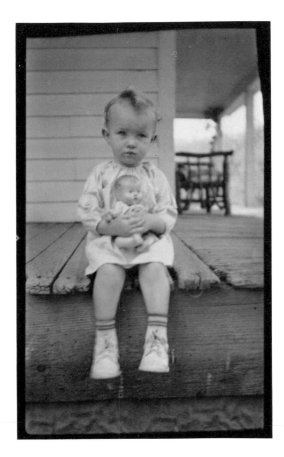

24

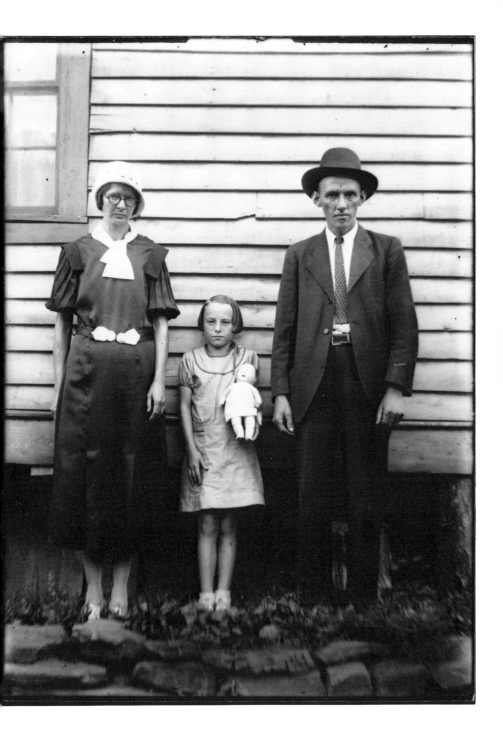

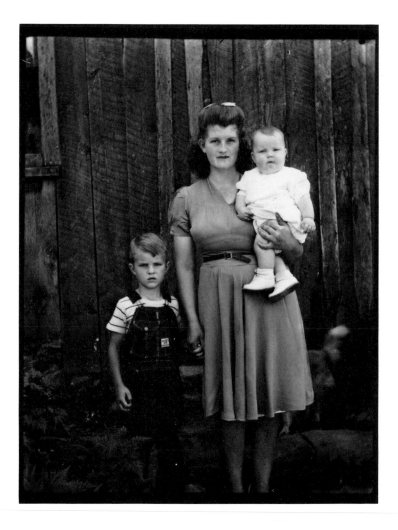

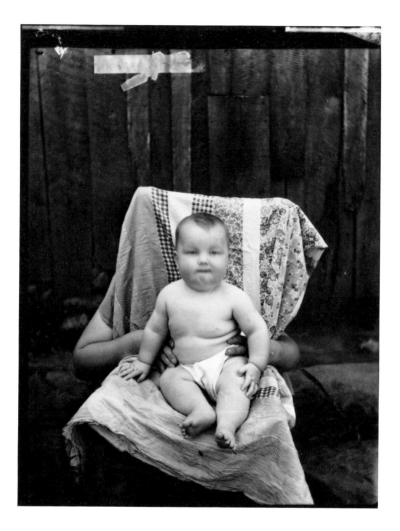

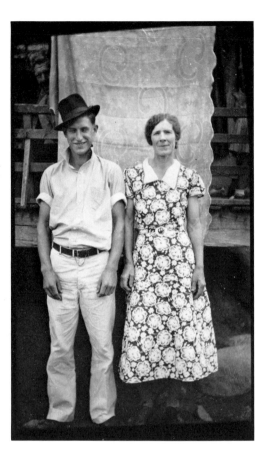

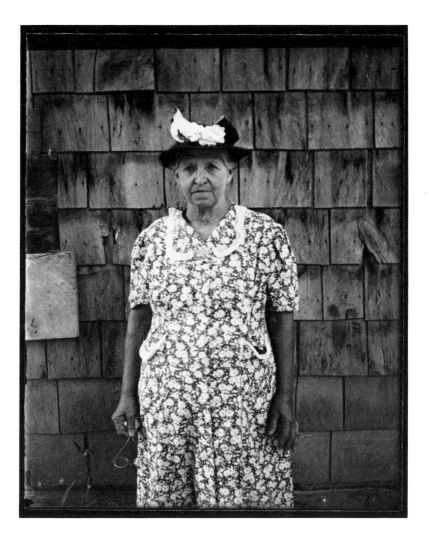

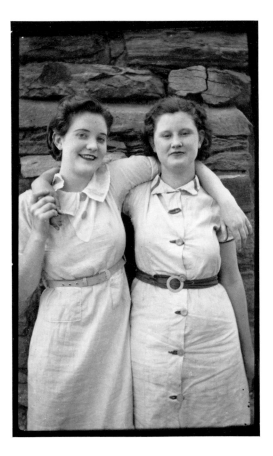

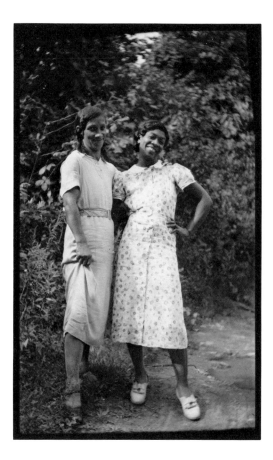

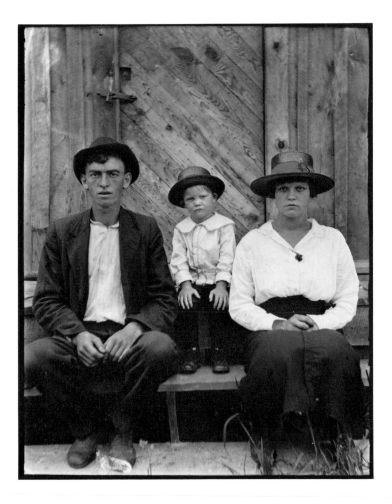

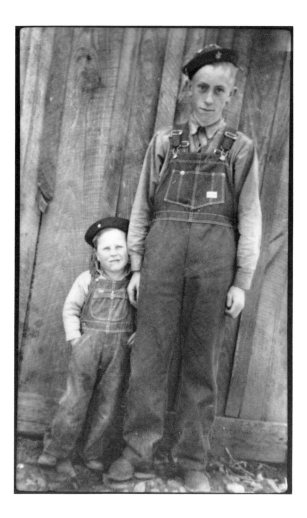

33

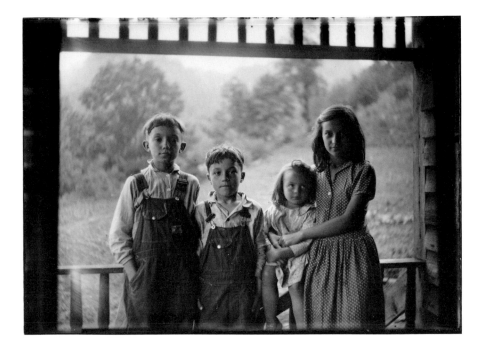

34

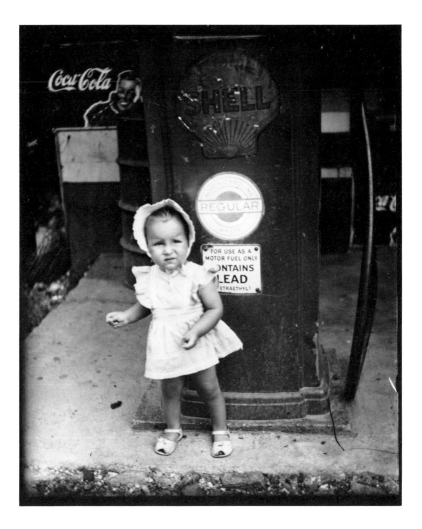

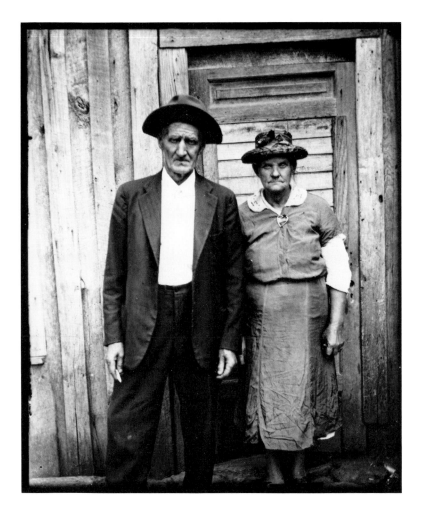

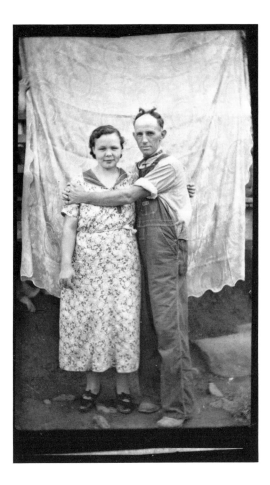

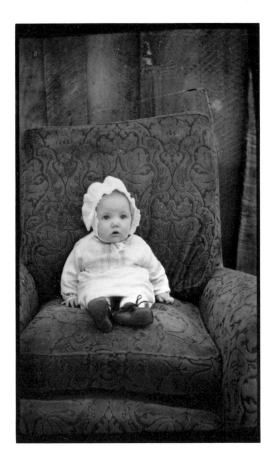

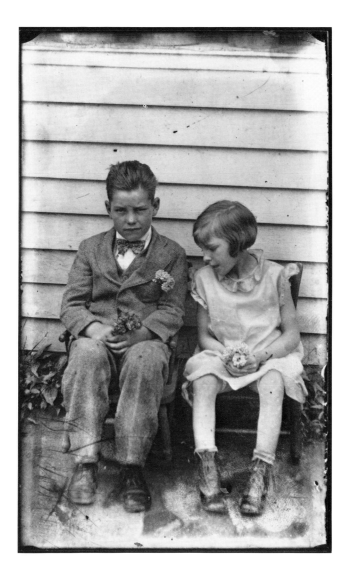

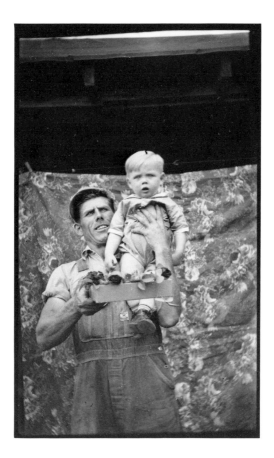

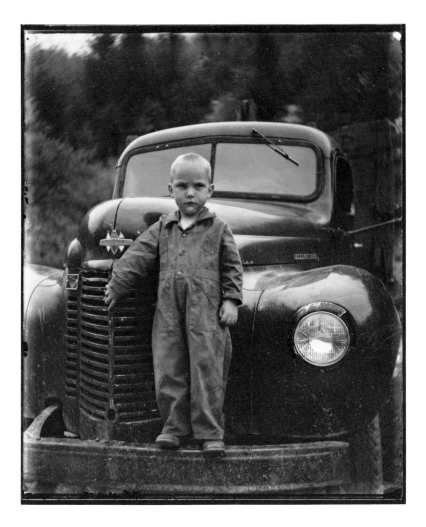

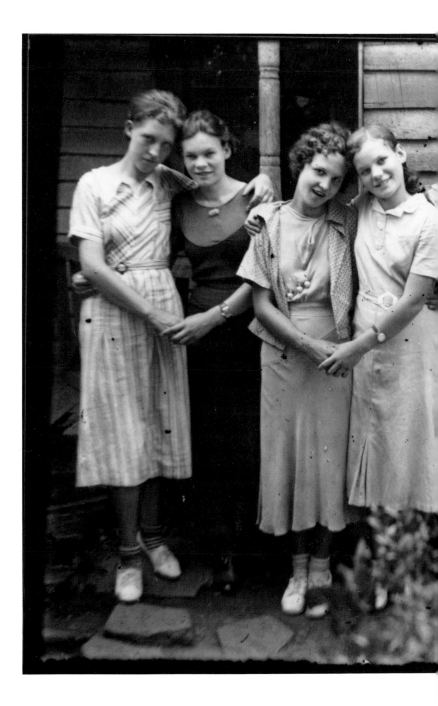

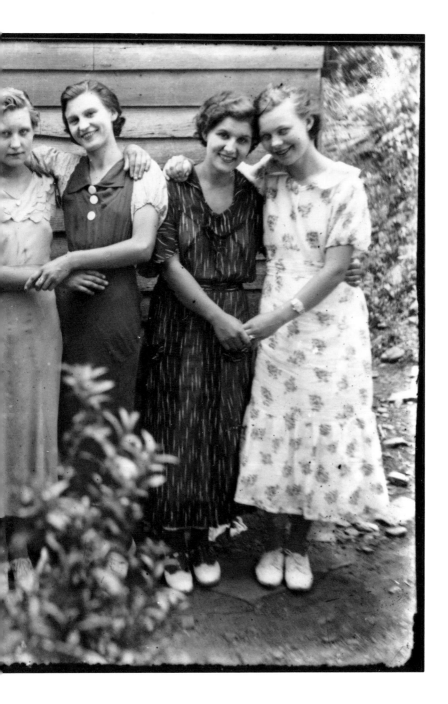

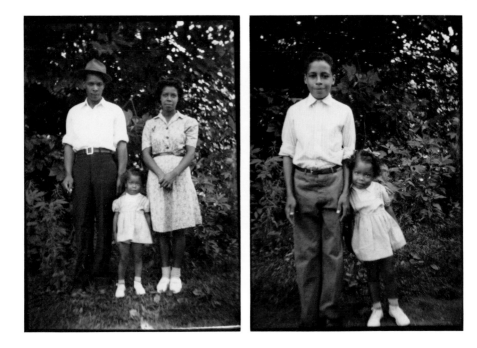

44

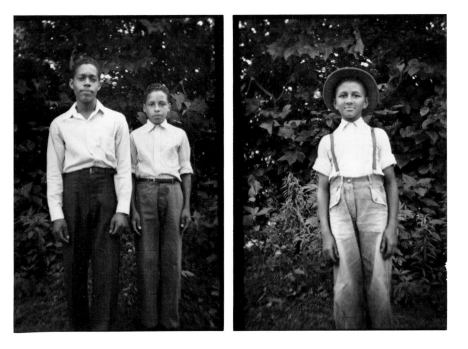

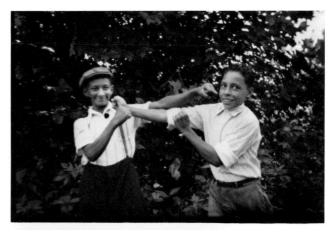

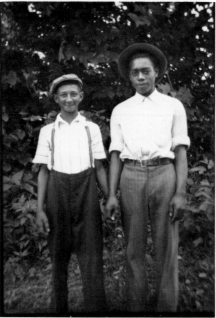

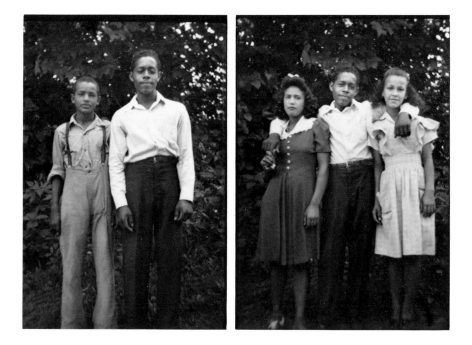

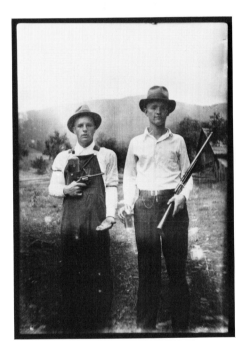

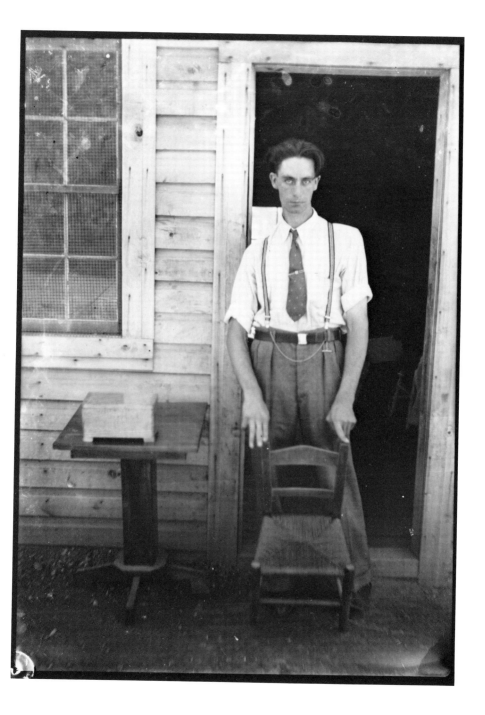

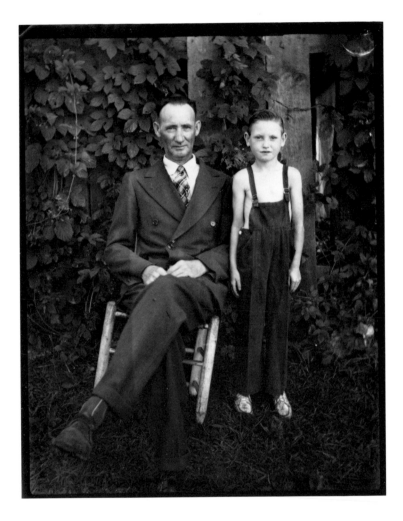

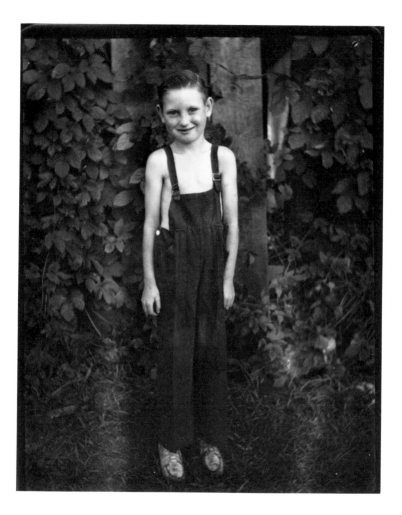

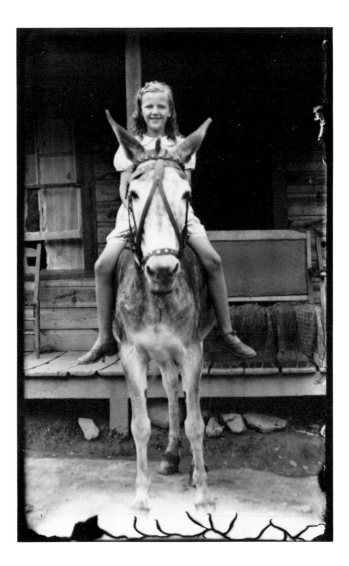

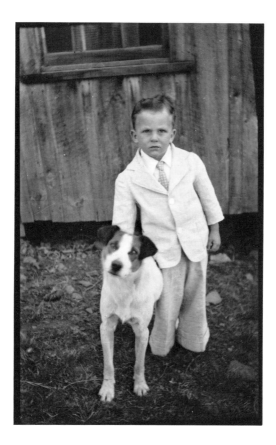

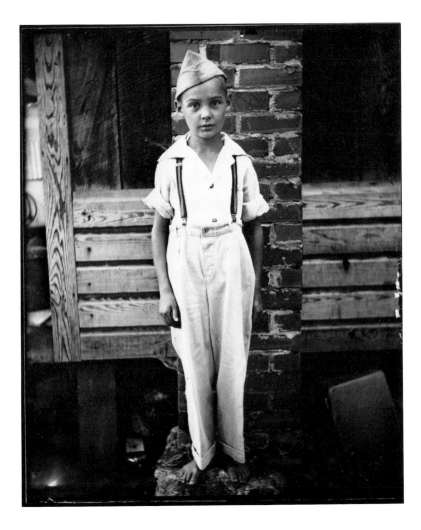

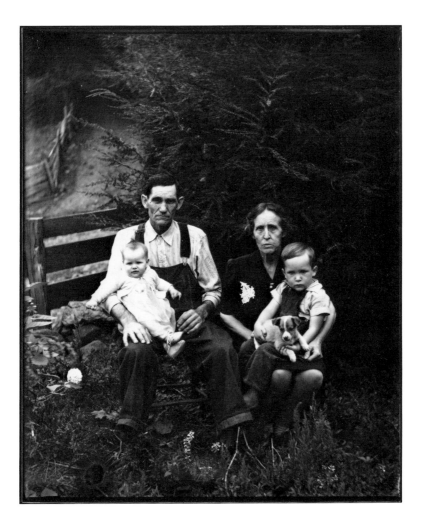

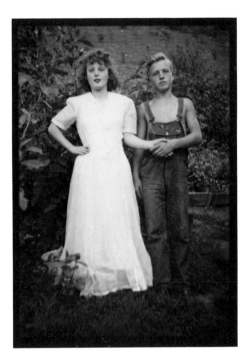

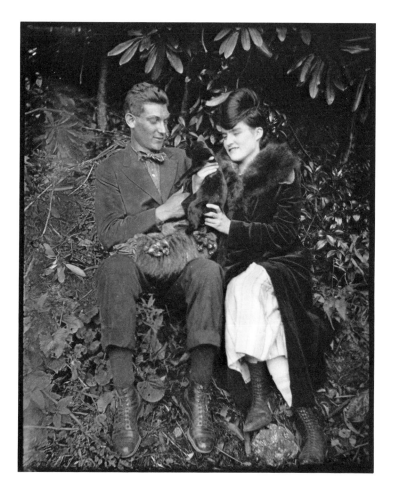

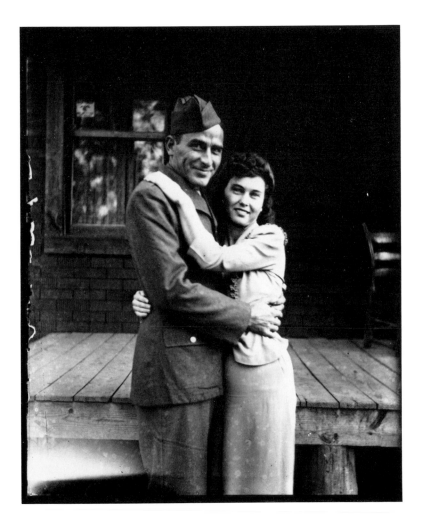

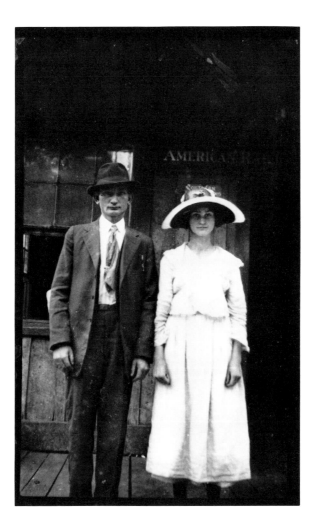

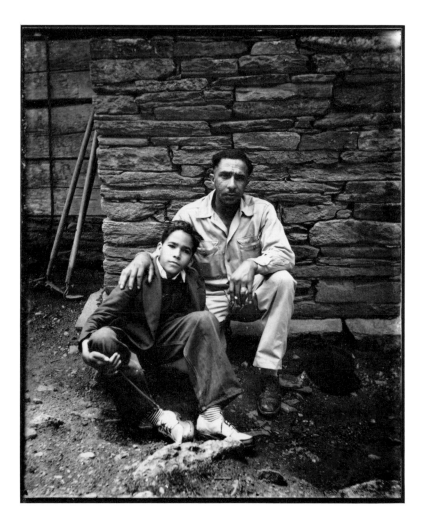

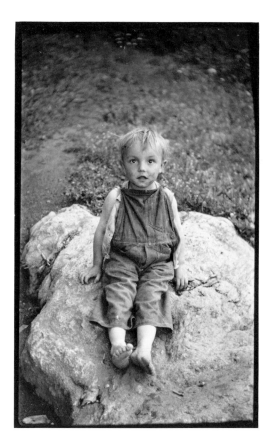

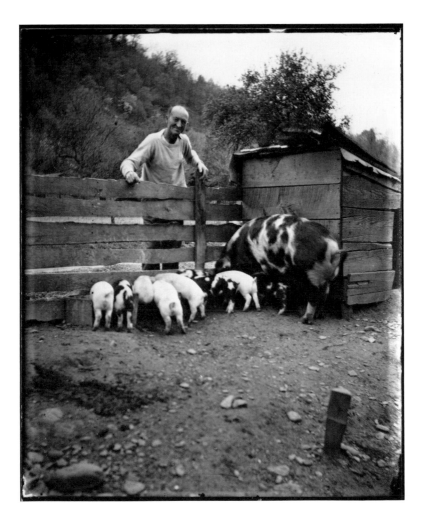

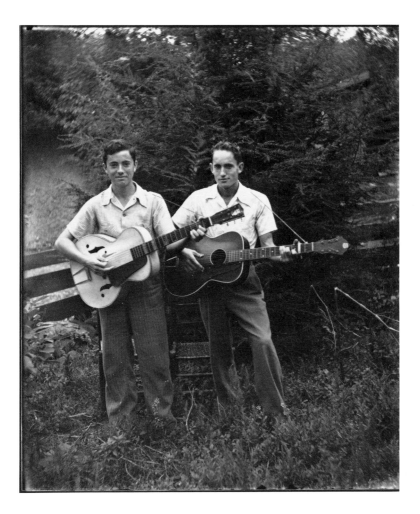

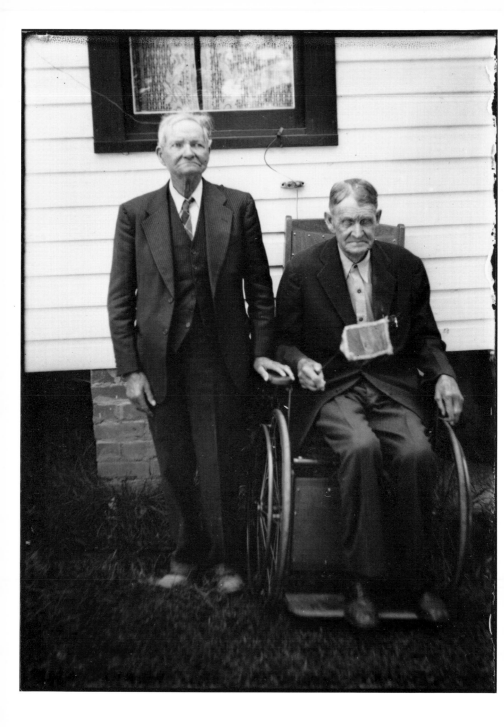

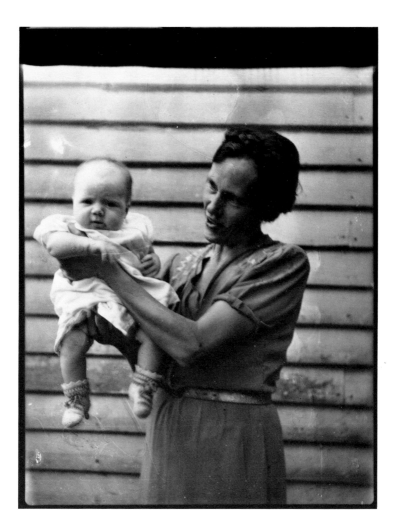

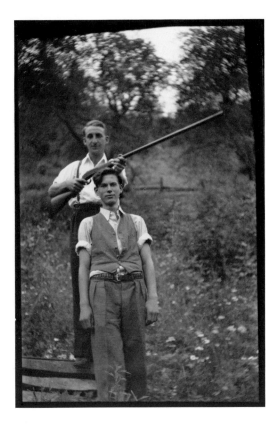

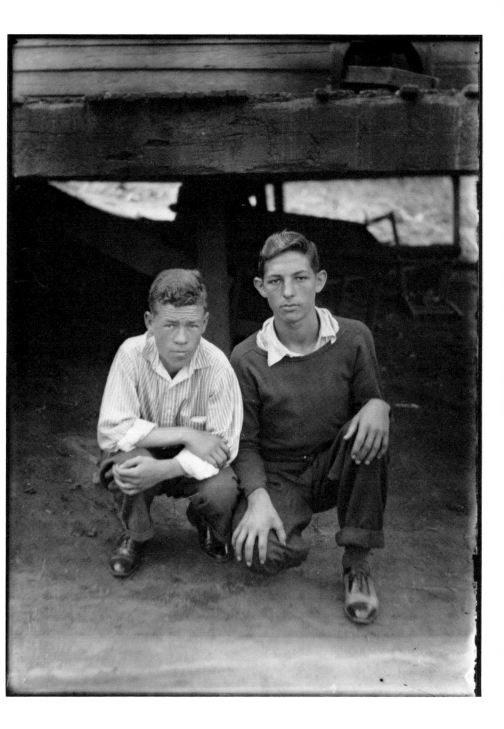

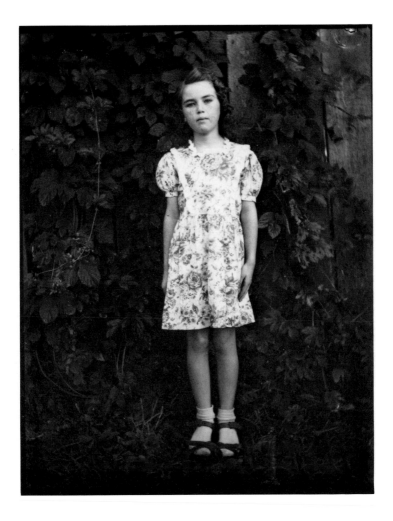

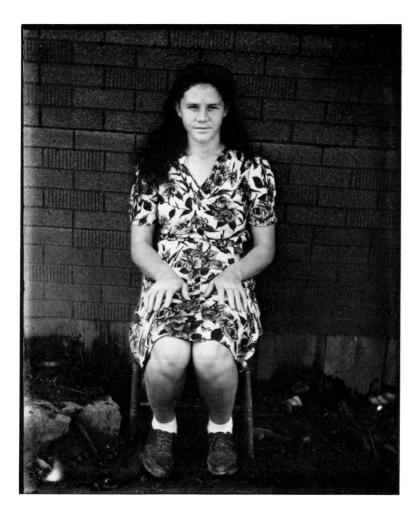

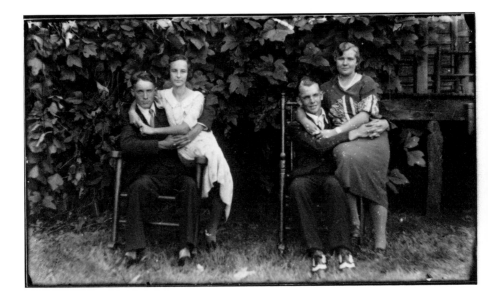

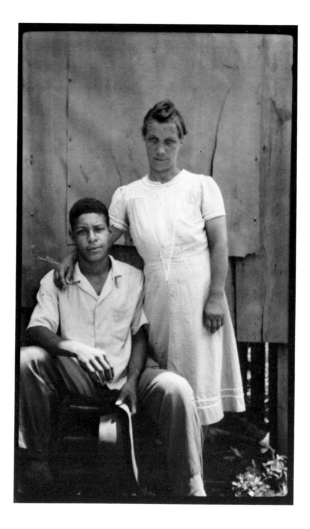

71

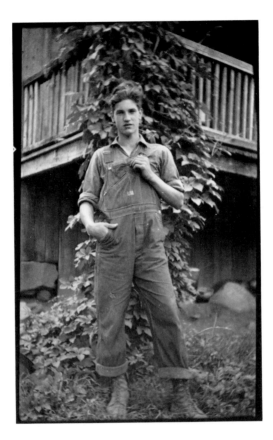

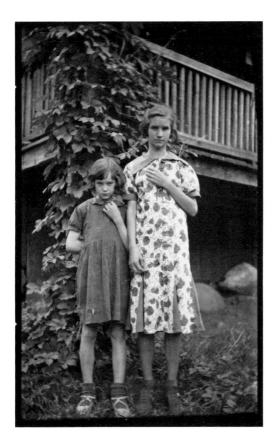

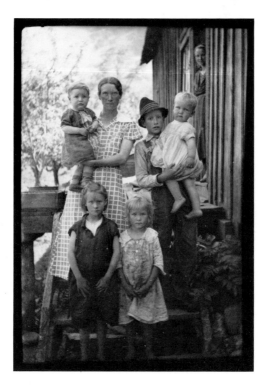

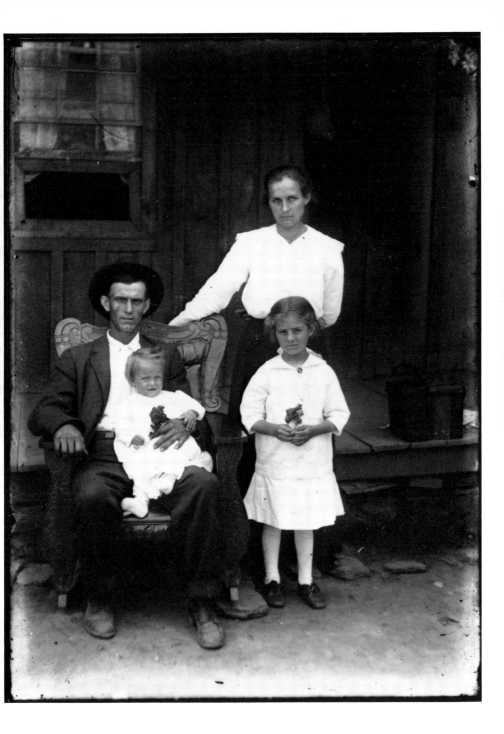

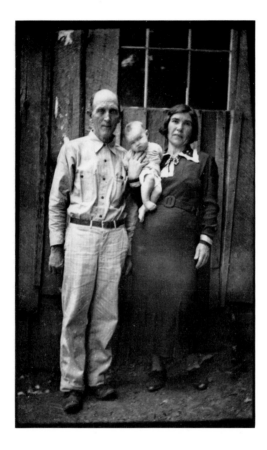

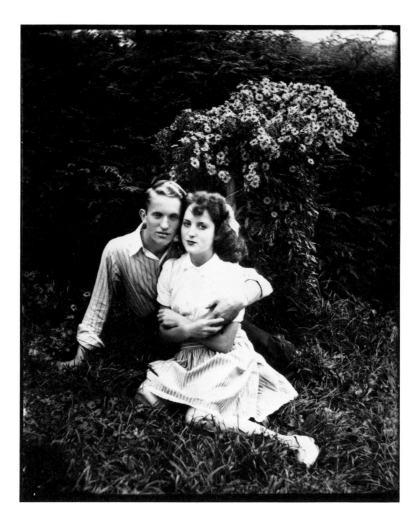

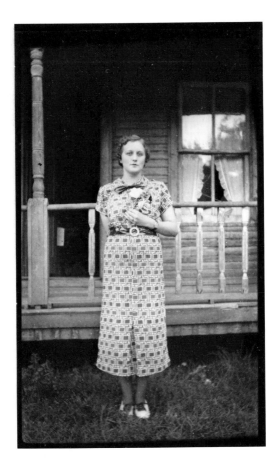

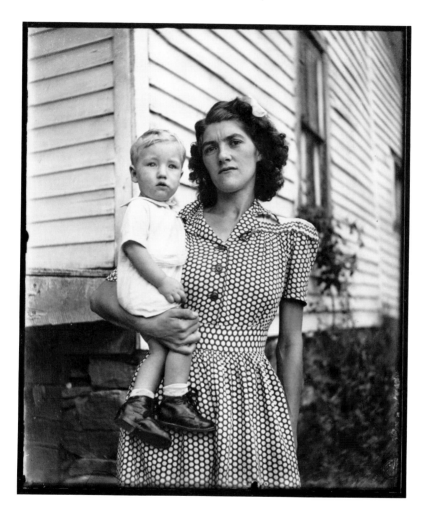

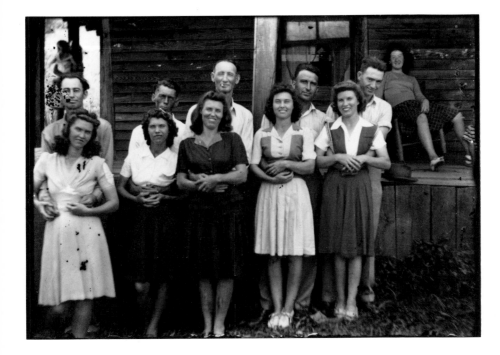

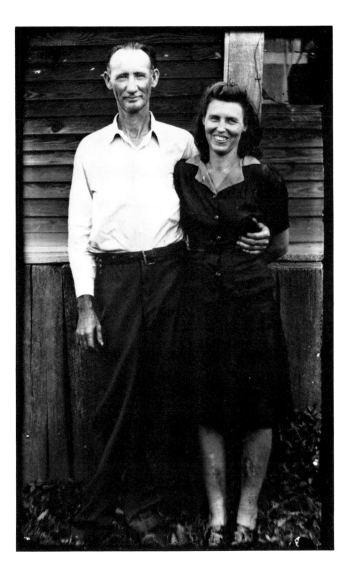

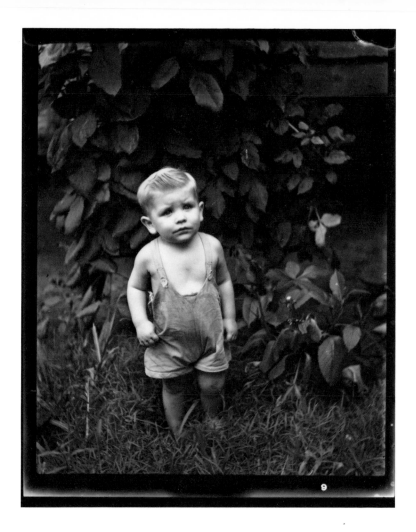

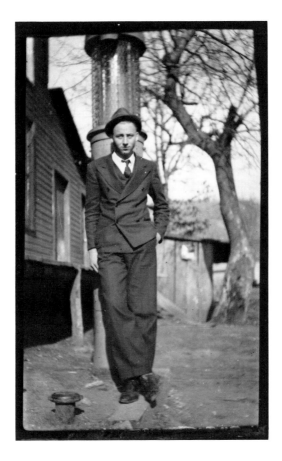

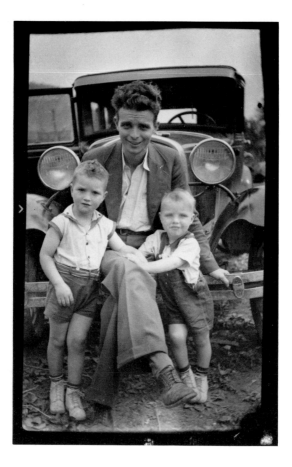

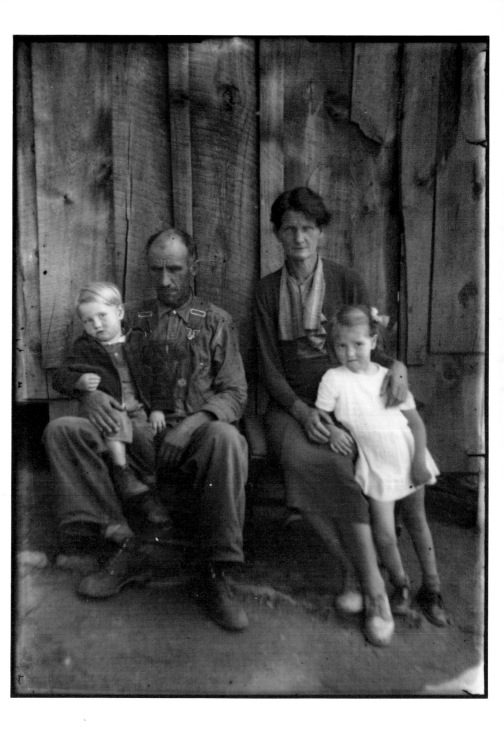

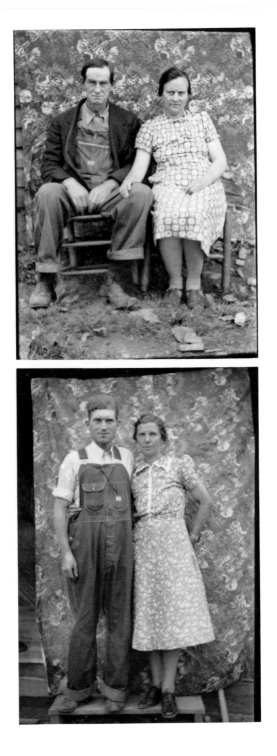

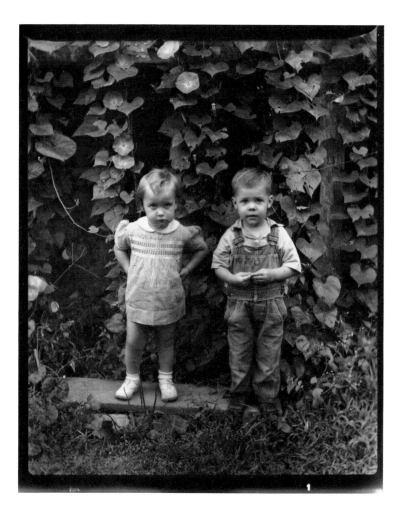

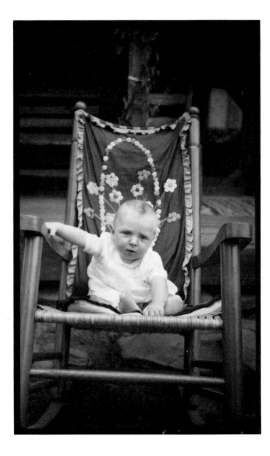

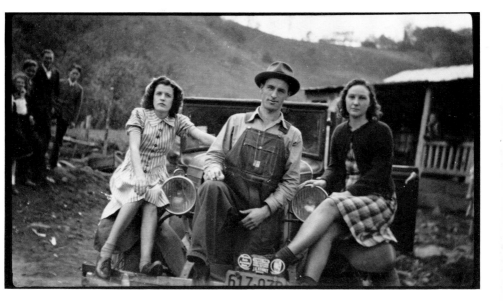

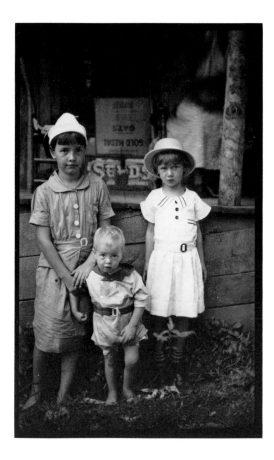

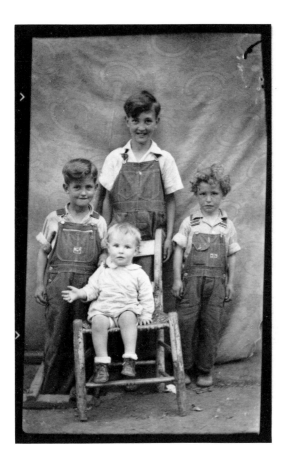

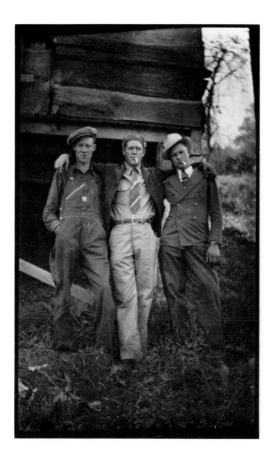

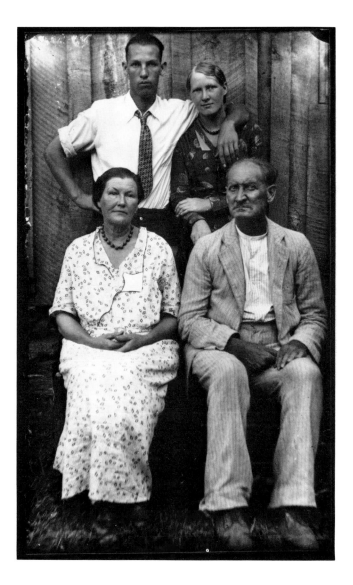

93

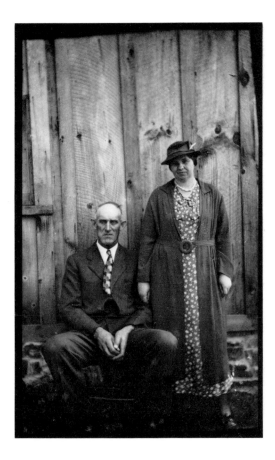

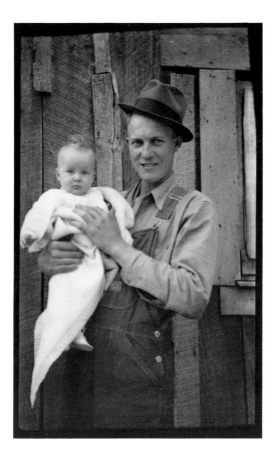

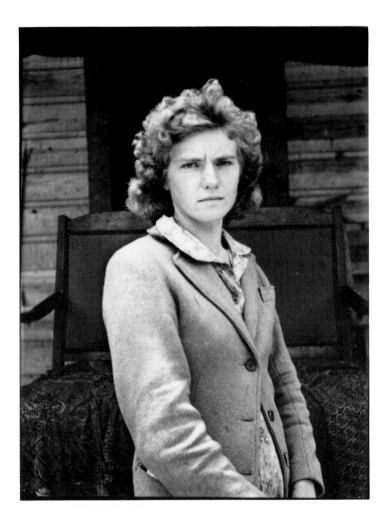

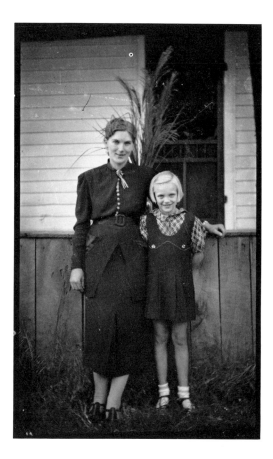

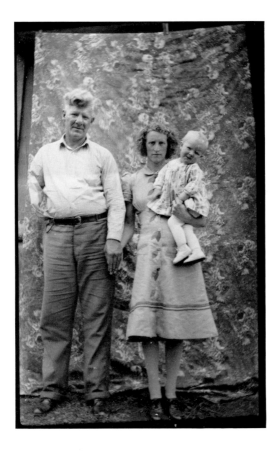

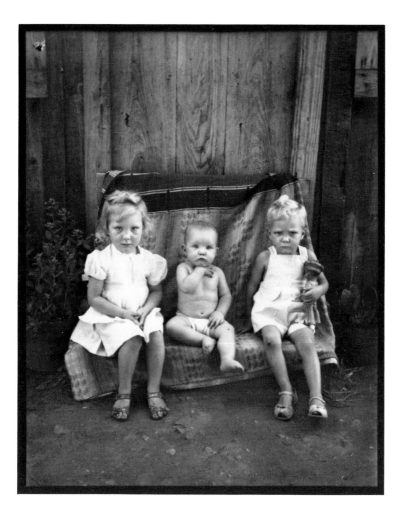

NOTES ON THE PHOTOGRAPHS

Paul Buchanan's original glass plate and sheet film negatives were contact-printed for this book. They are reproduced here the size of the negatives. The few exceptions are those noted below as 5" × 7" negatives. The subjects chose the negative size, which determined the price of the photograph.

Photographs of Paul Buchanan were made by Ann Hawthorne during the session described in the Preface.

p. 12 5" × 7" negative

p. 13 Irwin and Louisie Buchanan, Fate's parents, Paul's grandparents

pp. 16–17 5" × 7" glass plate diptych (two images on one plate)

p. 34 5" × 7" negative: Paul Buchanan's children

pp. 42–43 5" × 7" negative: Paul's nieces. This photograph was their payment for hoeing his corn.

pp. 44–47 Buchanan recalled that these photographs were made in Lick Log. They comprise the largest collection of his images from one session, where the subjects pose themselves in varying combinations while the camera rarely moves.

INTERVIEW

(From tape-recorded conversations between Ann Hawthorne and Paul Buchanan, Hawk, North Carolina, 1985.)

Ann Hawthorne: How did you get started taking photographs?

Paul Buchanan: My daddy. He imparted it. I don't know how he started. That was pretty close to one hundred years ago. I don't know how he got started. There's nobody living now that I could ask. It could have been from mail order. He's the onlyest man around this country anywhere that done that kind of work.

Fate Buchanan—everybody always called him "Picture-Taking Fate." And that's what they called me: "Picture-Taking Paul." Yeah, Picture-Taking Paul. "There comes the picture man."

AH: Did he teach you?

PB: He'd tell me all he could. If he'd see I'd made a mistake on something, he'd correct me on it. If I'd make one too light or too dark or something like that, you know. If I'd get too close to them, or too far back. When I'd be a'drinking, I guess, I'd do that a lot of times. He'd tell me about it, you know.

I never did travel with him. I just watched him, you know. When I got big enough—when he'd be gone, I'd want some [prints] of my own. I'd slip into his little room [darkroom] and make me a bunch. It was just a small room. He had an enlarger. He hardly ever used it. He just made them by natural size [contact prints]. Used a kerosene lamp with a colored glass. I've still got it, but I've got it rigged up with electric now.

My grandson's got my tripods and cameras. My black cloth's up in the smokehouse. My cameras—they's over a hundred years old. They were my daddy's. Yeah, they belonged to him.

I'd have his films yet if it hadn't been for a big rain. Come a big rain and he had them out in an old building. That rain just come in and covered them in sand and mud and ruined them.

I have an idea I started taking—snapping—pictures when I was around sixteen, maybe seventeen. When I was slipping into my daddy's little room—when I was doing that I was a whole lot younger. I'd just pick out what I wanted and make them.

When I started he'd let me use his cameras. I don't know how he got them. He never did leave this country.

AH: Do you remember the first picture you made?

PB: I remember the first day but I don't remember where it was the first picture or not.

I was making a Sunday school picture on Hinson's Creek. I'd forgot when I went to snap where'd my lens stayed open. And I overexposed it. I had to snap it again.

They got me again to make a Sunday school picture. I made it and an old preacher's wife, she took three of them. I don't know what she wanted with three. I went on up the road. A fellow up there had two crippled girls. They was deformed, you know. Doctors wanted pictures of them. He had me to make them. He kind of stripped them so I could make it. So while I was making that, that preacher's wife came up going to eat dinner with them people. She said, "Don't you know it ain't right for you to get out here and make money on Sunday?" I said, "It ain't a bit more right for a preacher to get down here and preach on Sunday than it is for me to get up here and make pictures on Sunday." And her done bought some of the Sunday school pictures I'd made.

Getting out that way you meet all sorts of people.

Wade Ledford over on Rock Creek wrote him a Bible. He got me to come over and make a picture of him and his girl to go in it. He was an infidel. When I went over to make that he said, "Paul, I guess you want to see what I'm doing." I said, "Yeah." He had what looked like three

or four tablets—writing tablets. I was sitting on the porch. He brought them out there to me. I began to read. Every hair on my head began to stand up, chills run up my backbone. I reached it back, said, "When you get your book wrote, I'll borrow one of your books and read it." It was about Jesus being a bastard and all such as that. If they hadn't been dead, I wouldn't have told you of it.

I guess back then everybody knowed me 'cause I traveled all over Mitchell, Yancey and Avery County—and McDowell. And just anywhere I thought I'd get some work to do, that's where I'd go.

When I first began, I traveled walking. But after I got—when I got me a car, that's the way I went. First old car I ever had was an old '28 Chrysler. Money's scarce back then. I had an old mare and she'd foaled a colt. And I swapped that colt for the '28 Chrysler. And that's how I got around. From then on, I had it made.

My daddy worked the same way I did—only he traveled walking. He never did have no car. That was back before cars got started. He'd travel. He'd be gone maybe a week at a time sometimes.

I'd start out about daylight. Stay out sometimes after dark. Sometimes I'd stay all night at the last one. Sometimes I'd take a notion just to come on home.

AH: When did he stop taking pictures?

PB: He quit, I'd say, about the time I was nineteen years old.

AH: Was photography all he did for a living or did he do other work too?

PB: Yes, he did. Well, I might as well just tell you what he done. When he was born he was a seven-months young'un. When he was little, a little boy, there come an old Indian doctor through this country doctoring syphilis. As it happen he stopped at my daddy's daddy's. And he seen my daddy, an ol' puny-looking fellow. And he said, "Boy, I'm going to tell you something. I'm sorry for you." Said, "I'm going to tell you something you'll make some money at some of these days." He told him about a root that growed in the mountains that he could get. Told him what-all to do to cure syphilis and all kinds of venereal diseases. My daddy took that up, too. Between that and the picture business he made good money.

I used to know how to make it. I used to make it up for him. One root was yellow sarsaparilla, but the rest of them I forgot. Now he made money on that. There'd come people from Tennessee and around from everywhere. Gosh, it'd cure them. After they was well, they'd be checked. Couldn't tell they'd ever had it. Back then that was the onlyest way to treat it.

AH: How old would your daddy be now?

PB: He'd be over a hundred. He's eighty-four year old when he died. I guess he's been dead twenty-five year now.

AH: How did you work?

PB: I'd gear up. You know how heavy those things [cameras] can be. I'd just take off. I'd take that five-by-seven camera and enough to make—well, if it was films, I'd take as many packs of films as I wanted. But if I was making on plates [glass plates], I'd have to take them along with me. One time's all I remember taking them along to reload.

To begin I always had plates and film too. And then I'd take that four-by-five. And then before I got it stoled, I'd take along that 116 Kodak. And then I had a 120 Kodak. I've still got it yet.

I made postcards—four for seventy-five cents. Five-by-sevens were four for a dollar. Now folks up Lick Log, they'd have [pictures] made on that 116 or 120 one, on account of it being cheaper.

AH: The smaller the film size the cheaper the picture?

PB: Yeah, on that 116 or 120 I'd make four of them for fifty cents.

AH: And you gave them the choice?

PB: Yeah, just whatever they wanted. I'd make them however they wanted them.

There's a bunch of boys. They'd had a decoration up on Bear Creek. People passing by, you know. There's a bunch of boys. I guess there's half a dozen of them. Wanted theirs made nude. Back then there's blackberry briars below the road. They put one boy up the road watching and one down the road so's if anybody come along he'd let them know. That one where was up the road, he come running. Says, "Here comes a bunch of people." Them boys were plumb naked. They jumped off below the road, run through them blackberry briars. The boy hollered and told them he was joking. They come back. Boy, they's about to skin him. They's bleeding all over. Those blackberry briars had scratched them all over. I don't know what they wanted with them [pictures] that way.

Did you ever find any old films you shouldn't have found?

AH: How much did the equipment you carried weigh?

PB: I have an idea all of it weighed forty pounds. Them cameras are pretty light.

AH: And you'd just take off walking?

PB: Yeah, uh-huh, yeah. Up until I got me an old car.

AH: How did you decide where to go?

PB: I'd just get to studying which would be the best place to go and take off.

AH: How far in one day?

PB: Back then I was young. I could go a long way.

Lots of times I'd stop at a place, they wouldn't be at all interested. I'd begin to show them my samples. They'd say, "Yeah, I believe I will have some made."

One time there was this ol' gal. Her boyfriend got killed in the war. That was back in wartime. I showed her my samples. She just looked at one. I believe I asked four dollars for it. And she said, "I want something better than that." Well, I picked another one up the same price and said, "Here's a higher one. Don't guess you want it." And she asked me how much. I believe I told her six dollars. "That's the one I want." It's the same price but thinking it was more made her happy. Didn't make me happy though—the wind of it. I got it done and took it back to her. She said, "I ain't got the money to pay you today but the next time you pass I'll have the money." I never did get a penny. I remember all such as that.

I didn't use props often—mostly when people would come to my house. Sometimes they'd write ahead; sometimes they'd just drop in.

AH: And you shot events?

PB: They'd come tell me or write me one. I done a lot of traveling. One time they sent for me to come to a church back up in Avery County. I forget what was the name of the church. I know where it was at, but I forget the name of it.

I went up and told the preacher I'd come to make that picture of the Sunday school group. Well, I just went out to get set up—ready for when they broke, you know. He [the preacher] got to wanting me to explain to them what I was going to do. I had took an old fellow with me and the preacher said to him, "Mr. Buchanan's gone out to get ready. You come up here and tell about it." That old boy where's with me, he said, "I'm a'gonna get you when I get home." Said, "Causing me to get up before all them people making a talk." He had to get up and tell about me making them [the pictures], how much they'd be apiece and so on.

They was having a reunion. I guess you've seed the road between here and Burnsville says Bearwallow Road. We went over there and went to Bearwallow Road and was making pictures then. I met them over there. Asked

me if I cared to ride on the back end of a truck. They'd hold all they could get on the truck. And I told them, "No, not a bit." An old man who owned the truck, he had, I believe it was two or three dollars' worth of pictures made. I made him pictures. I always didn't collect nothing 'til I got them made and let them see them before they paid me. So when I took his back and gave them to him he said, "You owe me for going over there with you. I'll just take the pictures for the debt." Them people that got me to go, boy, that made them mad. 'Cause they's supposed to furnish me the way. I didn't have no car at that time. They didn't like that a bit—him a'charging me. I run into every kind of person, though.

I made a man's picture one time. I made them and when I took them to him he had his eyes shut. He didn't want to take them. I got pretty mad at him. I told him, "Hell, I couldn't keep your eyes open." It wasn't my fault. I forget whether he took them or not. He didn't like them on account of having his eyes shut. Just as I snapped, he batted his eyes. Now young'uns you could figure, but a grown man should have kept his eyes open.

They'd most of the time tell me they'd like for me to come make their young'uns' pictures or some of their family. We'd just get down and make them.

I'd pick out the place to make them mostly. I had a background. I'd stretch it up on the house. It's just an old

piece of cloth. I didn't use it on too many if I could get away without it. It was just cloth and hard to put up.

If I could I'd find a pretty bunch of flowers. And I'd have to wait for them. I got so tired of waiting on people to get ready.

There's one time—this made me pretty mad. I was up in Avery County and I had a blow-out. I had to go around the curve. I took my wheel off and went around the curve. I had my Kodak. I just had a little old 116 Kodak that day. I took it off my seat to keep anybody from seeing it. Put it under the seat. I had to roll my tire down to have it fixed. I had it fixed and brought it back to my car and started to get my Kodak out from under my seat. And, by golly, somebody'd stole it. I had some pictures where I'd took on the film, you know. There was a bunch of people above the road hoeing taters. I have an idea some of them seed me put it under there and come and got it. I never did hear no tell of it. That was an old Model A Ford. Didn't have no way of locking it.

AH: What counties did you cover?

PB: Mitchell and Avery and Yancey and I worked a lot in McDowell. It's a long way to go. They's some territories I'd go in and nobody wasn't interested in pictures. Some I'd go in, and everybody wanted one.

AH: What made that difference?

PB: I swear I don't know what.

AH: How often would you go back?

PB: When I'd go and take them, I come back home and finished them up. Then I'd have to take them back. If I didn't take any that go-around, I wouldn't go back maybe for two or three years. As long as I could take enough to pay me to go back, I'd go back and keep going.

Pittman kept a store down here. I went in looking at me a hat. I told him if I made forty dollars that day, I'd buy the hat. I went on. And I'd made nearly forty dollars. And I'd come back down to another hollow. I thought I'd go up that hollow and make enough to make my forty dollars. I went up that hollow. And when I come out of it I'd made sixty dollars. And I come back. I never did get my hat. I believe that was Birch Creek.

AH: When you went up a hollow like that, how did you work?

PB: Once in a while I'd stay all night. But I'd generally go there and come back in the same day. I'd just go and knock on doors. I always had me some samples with me. If they was interested—look at them samples.

I just stopped at every house and asked them if they needed any picture work they'd like to have done. I just made their picture and their young'uns' pictures. And then

I'd follow to send them to New York to have them enlargements and colored. Back then wasn't nobody around here couldn't do that kind of work. I'd send them there.

I'd write the people a postcard sometimes and tell them I'd be there a certain day. When I'd go, they'd gather in. And I'd finish—run out of all the picture stuff—films—before I'd get through.

I remember going to a place and I didn't have frames [film holders] enough to hold all my plates. That's when I was making them on plates. I just took a box of plates with me if I run without. I just had enough to make maybe a dozen. I took extra plates with me. I figured I could find a dark room over there somewhere to load them. I had to load them in total darkness, you know. I asked a woman where if she knowed where I could find a dark place to load them. And she said yeah, her basement. And she went with me there to show where it was. I had to make three or four trips up there to load that.

I stopped at a house one time. I forget if I knocked or hollered. Anyhow, an old man come to the porch. "What in the hell you want here?" I said, "I heared your wife was dead. I thought I'd stop and see if you had any picture work you want done." I allowed if he had a picture of his wife he might want enlarged. "Hell no, I ain't got any I want." I just turned and walked off and never said more.

Used to be, I'd start out. By the time I'd get to the foot

of Lick Log, everybody'd be ready for me again I'd get to their house. That was the best place I ever went about that. I didn't have to wait on none of them. They's a'looking. Some little boy'd see me and run on ahead. Say, "The picture man's a'coming!"

They'd say, "You're the best picture man ever I'd seen in my life." Everybody always claimed I was a good hand. I didn't know if they was just bragging on me or what.

There's old pictures I made that's as good as ever they was as the day I made them.

Used to be two old queer boys lived up in Avery County, James and Gene Hicks. You may have heard talk of them. There's one time I made Gene's picture. He had about three coats on. When he'd see me over there, he'd go with me, you know. He run on ahead of me and tell them, "The picture man's a'coming." I'd made me one of his pictures for a sample. I knew it'd be a good one when we's up there. And it was just like him. Well, I had it in the car and I run it up there with him, up there to Powdermill. I said to James or Gene one, I forget now which one—I said, "Wait a minute. I want to show you something." I got his picture out. I showed it to him. "That's me! That's me! That's me, by George!" He took off and running to the store showing his picture and all. He brung it back and I just give it to him. You know, boy, that pleased him to death.

One time an old colored woman. I'd made her picture. She had her dress up to about here [her knee]. She's standing there looking at it. She said, "You know I has got a pretty leg, ain't I?" I said, "You sure have." And she pulled her dress up to show me. This was up on Lick Log.

AH: Did you go out every day?

PB: No, just once in a while. Mostly on Saturday and Sunday.

AH: What did you like about the work most?

PB: Just getting out and around. Meeting people.

AH: Would you spend time talking with them?

PB: Oh yeah, a lot of it. Yeah, a lot of it.

AH: So it was work but pleasure too?

PB: Yeah. I know I had a pretty good time out traveling around meeting people. I like meeting people. I'm an awful hand to talk.

I'd always heard them tell of an old colored man married a white woman. Yeah, a colored man and a white woman got married. I stopped at a colored man's house one time. We's talking. I was sitting talking there with him. I said, "I heared one time of a white woman marry-

ing a colored man." And they was trying them. Back then, you know, they'd try them over it. It was against the law for them to marry. Before she went to trial—she didn't want to swear to a lie—she cut his finger and took blood out of it. Then she went on and had the trial and she swore she had colored blood in her. And he said, "Right in there sits the woman that done it."

I didn't know I was talking to him. Talking too much.

AH: The prints you made were contact prints?
PB: Yes, I never did enlarge none. Other pictures they'd want enlarged, I'd send to New York.

I'm studying a lot about writing that company and seeing if they're still in business. If they was, I could get a lot of work that way to fill this gap. To have something to do. They'd put them in rings and all kind of pins. I made a lot of money. One that cost me eighty cents, I'd sell for four dollars and a half. I made money on that.

AH: You said you used to send pictures off to have handcolored.
PB: I used to have several of them around. I don't know what went with them. I'm going to write them sometime this spring, see if they're still in business.

One time I was out just getting them to enlarge, send them to that New York company. I went to an old wom-

an's house. She had it just propped up. Had props under each corner to keep it from falling in. I asked her if she had any pictures she wanted to have worked on. She got me two or three. I brought them, sent them, had them fixed. I guess the company done a good job on them. I took them back to her. Pleased her awful. She asked me if I could fix some more for her. I said, "Yeah, I'll fix all you want." She said, "Well, if when you brought them back, if I lacked a little money having enough to pay you, would that be all right?" I said, "Sure, that'd be all right." So I guess she had fifty or sixty dollars' worth. Maybe more than that. Well, when I took them back, she never mentioned nothing about charging. She just went and got her billfold and counted out my money. And she said, "You want to make some more for me?" I said, "Sure." I bet you I made her more than a thousand dollars' worth of pictures.

AH: Where did you enjoy going?

PB: Just about anywhere I went I enjoyed it. Yeah, I enjoyed it all.

AH: Would you do it all again—taking pictures?

PB: Yeah. If they hadn't changed stuff so to finish them up, I'd work at it a little along still again now.

A while back I was in a store wanting to buy the things

to make hypo. When he got it all ready I asked, "How much do I owe you?" Well, he began to figure out. This was four dollars, that was five dollars, this two dollars, such as that. I said, "My God, how much is it gonna cost me? I used to get enough to make a gallon for twenty cents." He said, "Let's just call it three dollars." "Well, that sounds more like it." He had it added up to twelve dollars. He said, "I just thought you wanted it." Back then—I've got the old bills now—it was twenty cents a pound. I think a pound made maybe a gallon.

AH: Would you advise anyone now to go into photography?

PB: If they felt like it, I would. Of course they could make money now where I couldn't 'cause money's nothing now. But then it don't buy anything. I made pretty good all along. You take, when I started out, if I made a trip making twenty dollars, I was doing fine. 'Cause twenty dollars then was twenty days' work. Dollar-a-day's what wages were back then when I first began in the twenties. I began it before we was married.

AH: Is the photography one of the reasons you married him?

Ola Buchanan: Yeah, it was.

PB: I'd be wanting to go and see her on a Sunday. I had a brother. He could take but he never did finish up none. I told him if he'd get out and take them, then I'd finish

them up and give him half of it. Well, he made a lot for me like that. I'd finish them up and he'd deliver them. I was wanting to go courting, you know. I could finish them up during the week and we both made pretty good. He was a good hand to take them but I was the only one in the whole bunch could finish them up. I had five brothers. I was the only one to learn it [photography]. I'm the only one living now.

AH: Were there other photographers around?

PB: Once in a while somebody would pop up and try it. They wouldn't last long. I was the only one around.

AH: Were people curious about your cameras and what you did?

PB: Well, not too much.

An old boy was laughing the other day. I run up with him. I hadn't seed him in a long time. I run up with him a few days back. Not too long ago. When he was just a little ol' boy, his daddy got me to come make his picture. Well, they got him ready. I got out and got ready. When I put that black cloth over my head, boy, he took off. His daddy never could get him back. I just had to come off and leave him. I never could get to take his picture. I scared him to death.

I bought films from George C. Dewey in Nashville.

They sold Kodak stuff. Yeah, I bought from George C. Dewey.

My boy lives five or six miles from Nashville. He said he saw their sign up over the store yet. If I was to then go visit him, I'd see about stopping in. I wrote to them over three or four years ago to see if they was still in business. I never did hear from them. I may take a notion to write them again. I might hear from them.

AH: How long were your exposures?

PB: One-fifth of a second. If it was a pretty day, I'd expose them faster. It all depended on how the weather was, you know.

AH: Did you ever use flash?

PB: No. Now my daddy, he used them a lot. But I never did. I guess he was just mostly wanting to try it out. See how it worked. He got us out one night late in the evening— might have been after dark—made our picture. It made the funniest-looking picture ever was. I reckon some of us jumped. It didn't do right at all. He was always trying out something new.

They called him "Little Fate" on account of when he was young he was real little. When he got grown he was a good-sized man. They called this mountain up here "Little Fate's Mountain."

My daddy always told me to leave them [prints and negatives] in running water for an hour. A lot of mine, I'd leave overnight. I had a place up here in the branch—a pipe running out. I'd have them in a dishpan and I just take them up there, put them under that, and leave them overnight. Well, that got all the hypo and stuff out of them. That's the reason they last so good. Leave one trace of that in there, that's the reason they fade. Another thing will make them fade is sweat—handling them with sweaty fingers.

I'd lay them [prints] on the bed to dry after I'd washed them. One day I had a bed full where they were drying. My young'uns were just little. Guess they got into that bed and just wrinkled them all. I had to make them all over.

When I'd go off and have two or three films left in the holder, I just made their [his children's] picture so I could develop the whole thing. It's hard to take some out of the film holder without taking them all out. I wouldn't waste any. [Picture on page 34.]

AH: Would people dress up for you?

PB: Biggest part of them. I could have done a lot better if they wouldn't. But the biggest part of them took a long time to get ready. Sometimes I'd wait maybe an hour. I just left it up to them. If they wanted to be made naked,

I made them. It didn't make no difference to me. The money was what I was after.

An old fellow was owing me so much. I thought I'd stop and see him. Well, I went. He was there. I said something about he's owing me. He said, "I'd of had that sent to you a long time ago." Said, "But I heared you was dead." Looks like he would have wanted to pay his debts if I were dead.

One time, I'd made a woman's picture. She'd give me a big old rabbit for making her picture—one of them tame rabbits. I was coming home. Another woman looked in and saw that rabbit. She said, "You mean tell me you make pictures for rabbits?"

AH: Did you often trade or barter for pictures?

PB: Anything they had to trade on I'd take it—like chickens. Back then peanut butter jars weren't like what they are now. I remember one time an old woman traded me a lot of peanut butter jars. I was wanting to put jelly in them. That was back when I was first married. I was wanting to put jelly in them. She traded me all I could tote to make her picture.

I had a lot of corn planted one summer. Back then, you know, times were pretty hard. They, my nieces, said they'd come help me hoe corn if I'd make their picture. That [the picture on pages 42–43] was the picture I made.

I made them all one apiece for helping me hoe corn. It didn't take us all but a little bit to hoe it out. I have an idea they had other clothes with them. They're my nieces. They made that pose. It's about 1940 just guessing at it.

I made so many pictures. I just don't remember who they are now. Looks like a pretty woman, I'd remember her. [Picture on page 96.]

I just know I made a pretty good living what time I worked with it. I done pretty good. And then, back in them days, I was pretty bad to drink. I'd start out in the picture business and get drunk before I'd get there.

The last pictures ever I took was a reunion up on the creek. The last trip I went out I had seventy-five dollars' worth. Seventy-five dollars then was a lot of money. When I got back home that night, I'd collected seven dollars. I thought, by George, I'd quit fooling with it. And I quit fooling with it and went to sawing chair posts. 1951—that was the last work I done.

AH: You had done other things than photography to support your family?

PB: Yeah, mica mining, sawmilling, such as that.

AH: Could you have supported them with just pictures?

PB: Yeah, I could have if I'd put full time into it. I could have kept them going pretty good.

AH: Why didn't you do it full-time?

PB: Dogged if I knowed. A few days now and then I'd get tired of it. Somehow I always did dread finishing them up.

AH: Are you proud of the work you did?

PB: Taking other people's word, I thought they were good. Everybody bragged on them.

If I did take them, they're good pictures. Good and plain.